P9-CBD-052

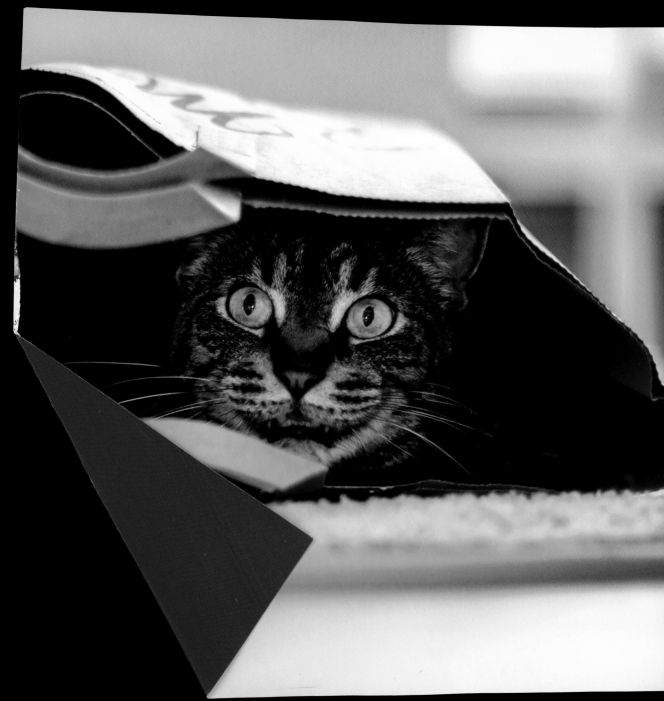

FOR SADIE, MY
FAVORITE FELINE.

Copyright © 2020 by Brooke Jorden.

All rights reserved.

Published by Familius LLC, www.familius.com

Familius books are available at special discounts for bulk purchases, whether
for sales promotions or for family or corporate use. For more information,
contact Familius Sales at 559-876-2170 or email orders@familius.com.

Reproduction of this book in any manner, in whole or in part,
without written permission of the publisher is prohibited.

Library of Congress Control Number: 2020939035
ISBN 9781641702942

Edited by Liza Hagerman and Sarah Echard
Cover design by Carlos Guerrero
Book design by Mara Harris
Photography credits: Shutterstock.com

10 9 8 7 6 5 4 3 2 1

First Edition
Printed in China

BROOKE JORDEN

CATS WILL BE CATS

THE ULTIMATE CAT QUOTEBOOK

FAMILIUS

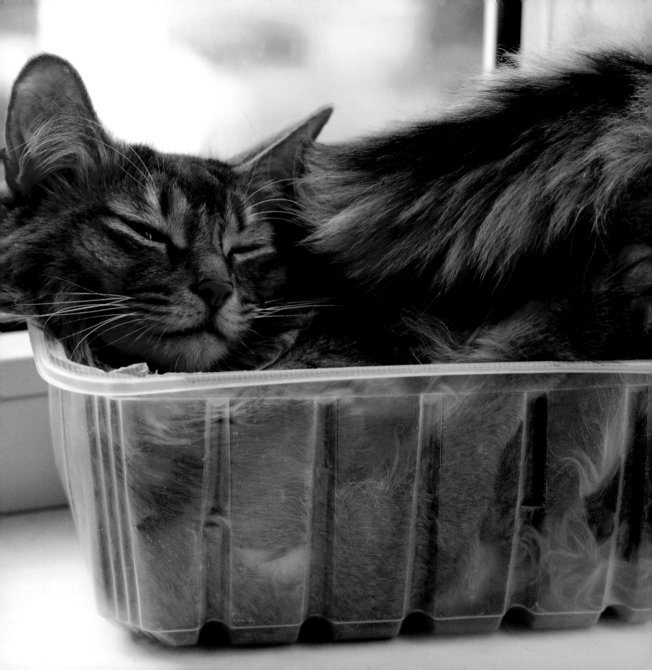

CONTENTS

CAT LOGIC:
AN INTRODUCTION

A caveat before I begin:

> **There is, incidentally, no way of talking about cats that enables one to come off as a sane person.**
>
> -DAN GREENBERG, AUTHOR

I accept this now, and I think I know why.

I haven't always been a cat person. My family owned various pets—dogs, rabbits, turtles, lizards—but my father firmly insisted that we would never own a cat. Cats, he preached, are evil. And so, I laughed when peasants used cats to beat rugs (*Monty Python and the Holy Grail*) and when Jerry dropped [insert a heavy object] on top of poor Tom.

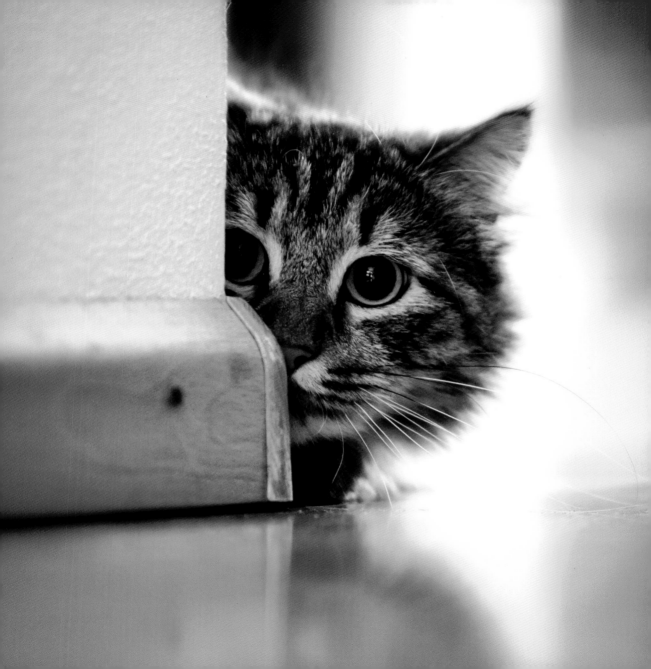

Years went by this way. I grew up, got married, bought a house, and then, one day, something changed. In a moment of clarity, I announced to my husband, "Let's get a cat." We adopted a beautiful orange tabby from the shelter near our home, and almost immediately, I was converted. Cats are so clean, so quiet, so graceful, and so deliciously curious—except for when they are whiny, clumsy, and unbelievably lazy. These intense oppositions crammed into such a small, furry body are fascinating.

I thought surely I would begin to understand our little Sadie with time; she was my first cat, I reasoned. And yes, with time, I grew accustomed to her odd habits and her particular needs, but I still never understood the whys behind them, and I'm not sure I ever will. Why does she stare at the walls as if she can see through them? Why does she insist upon drinking from the sink instead of her water dish? Why does she prefer the cardboard box to the wonderful toys that came in it?

Cats are just animals, some people may insist. That's all there is to it.

Maybe I'm crazy, but I suspect there must be so much more brewing behind those luminous eyes. The privilege of every cat lover—from artists and philosophers to crazy old "cat ladies"—is to wonder at the puzzle that is cat logic. As cat therapist Carole Wilbourn put it:

"The constant challenge to decipher feline behavior is perhaps one of the most fascinating qualities of owning a cat."

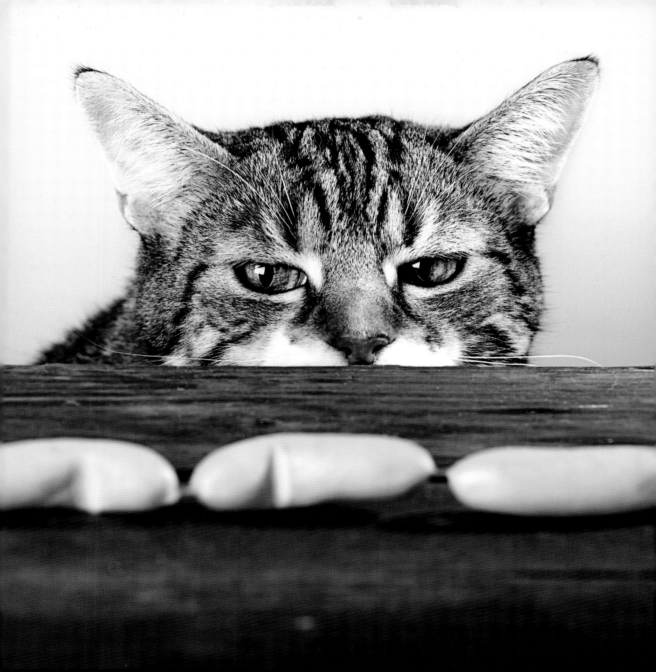

CARDBOARD BOXES
Cats and Their Peculiarities

Cats are persnickety. They tend to like things just so, and anything that throws off the status quo earns a piercingly silent glare. Cat owners can, eventually, understand their cat's habits and needs. More perplexing, though—and more entertaining—are the peculiarities that have nothing to do with habit or survival and everything to do with being a cat.

Cats can be impatient: "I think you should wake up and feed me NOW."

Cats can be indecisive: "The door's open, but should I stay inside or go outside . . . or inside . . . or outside?"

Cats can be stubborn: "I know you are calling me, but I'm going to take my sweet time about coming . . . and only because you might have food."

Cats can be particular: "I want you to rub my tummy, but only twice. And only with one hand. And only on my left side."

Like I said . . . persnickety. But we love them, anyway.

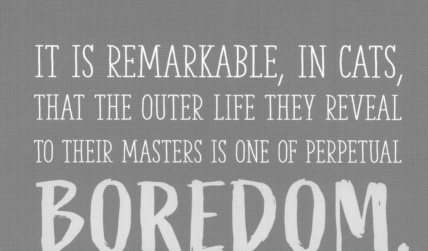

IT IS REMARKABLE, IN CATS,
THAT THE OUTER LIFE THEY REVEAL
TO THEIR MASTERS IS ONE OF PERPETUAL
BOREDOM.

-ROBLEY WILSON JR., WRITER

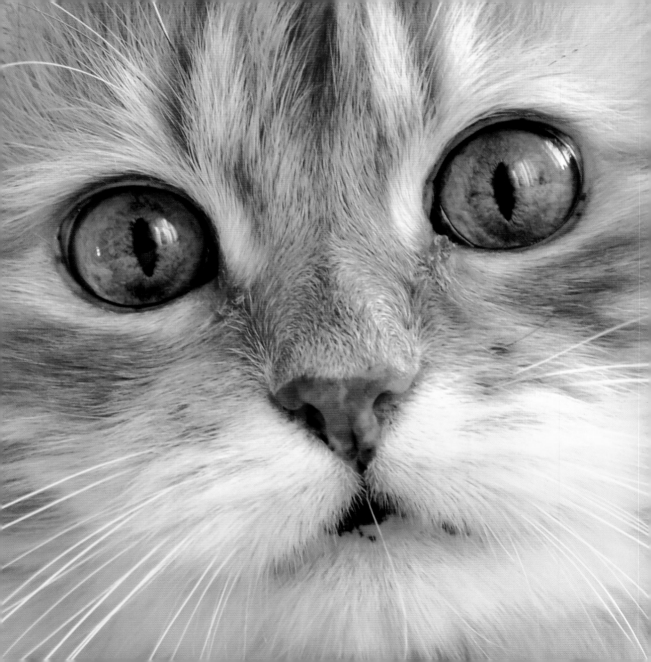

THERE IS NO SNOOZE BUTTON ON A CAT WHO WANTS BREAKFAST.

-UNKNOWN

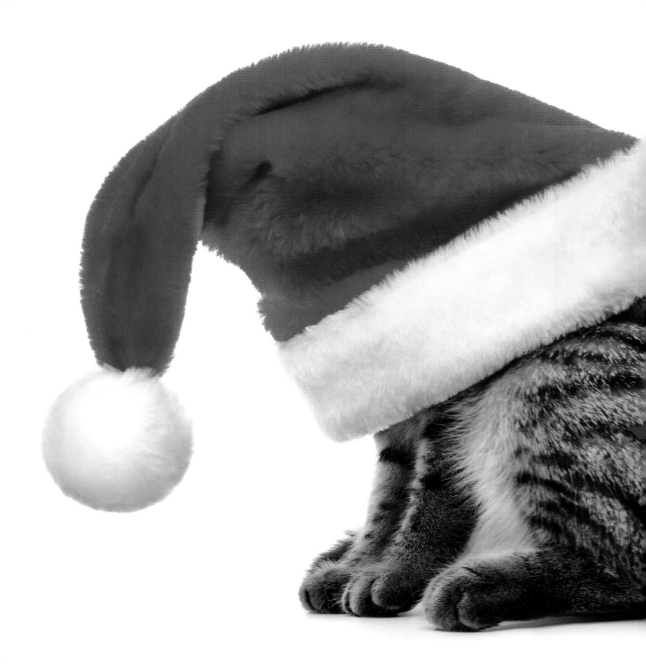

A CAT IS
A PUZZLE
FOR WHICH
THERE IS NO
SOLUTION.

-UNKNOWN

EVERYTHING COMES TO THOSE WHO *wait...*

EXCEPT A CAT.

-MARIO ANDRETTI, RACE CAR DRIVER

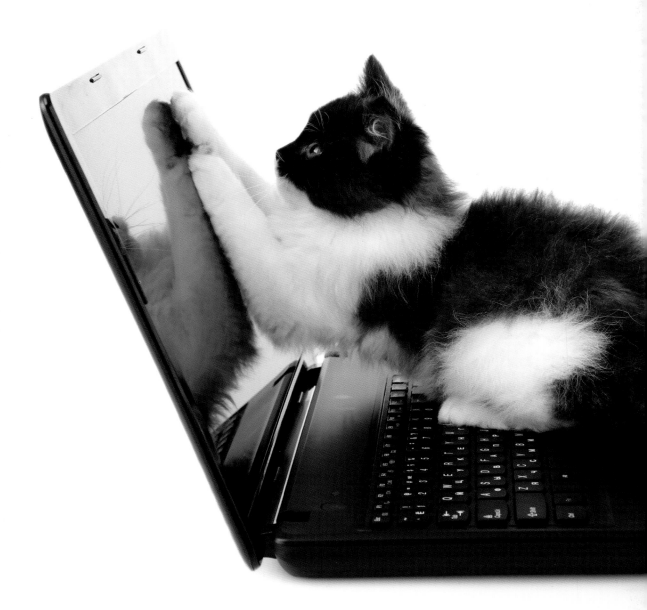

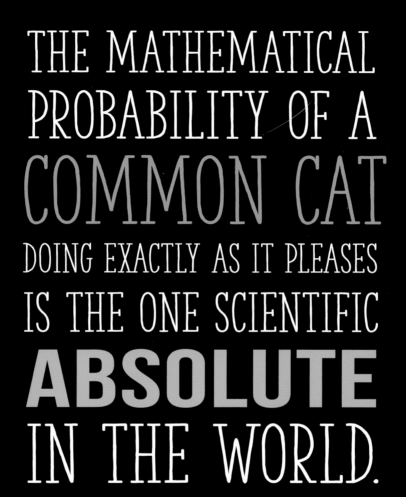

THE MATHEMATICAL
PROBABILITY OF A
COMMON CAT
DOING EXACTLY AS IT PLEASES
IS THE ONE SCIENTIFIC
ABSOLUTE
IN THE WORLD.

-UNKNOWN

MEOW

IS LIKE *ALOHA*—
IT CAN MEAN
ANYTHING.

—HANK KETCHAM, CARTOONIST

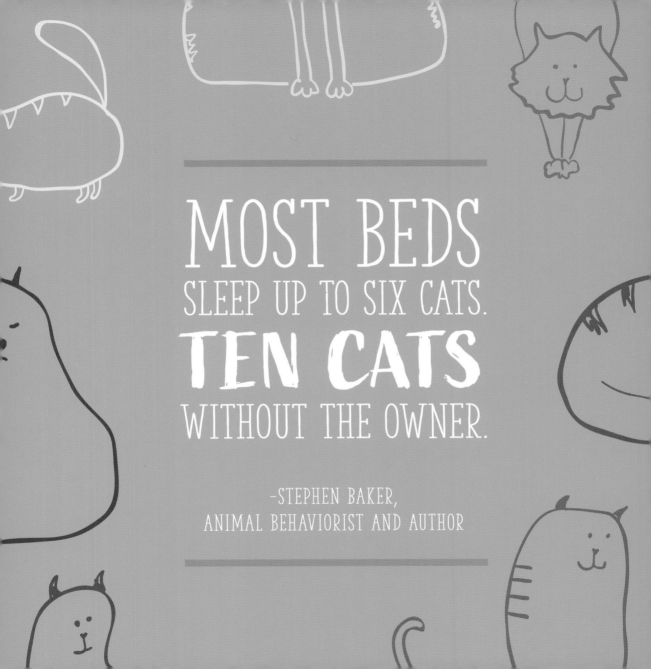

MOST BEDS
SLEEP UP TO SIX CATS.
TEN CATS
WITHOUT THE OWNER.

-STEPHEN BAKER,
ANIMAL BEHAVIORIST AND AUTHOR

FOR A MAN TO
TRULY UNDERSTAND
REJECTION,
HE MUST FIRST
BE IGNORED BY
A CAT.

-ANONYMOUS

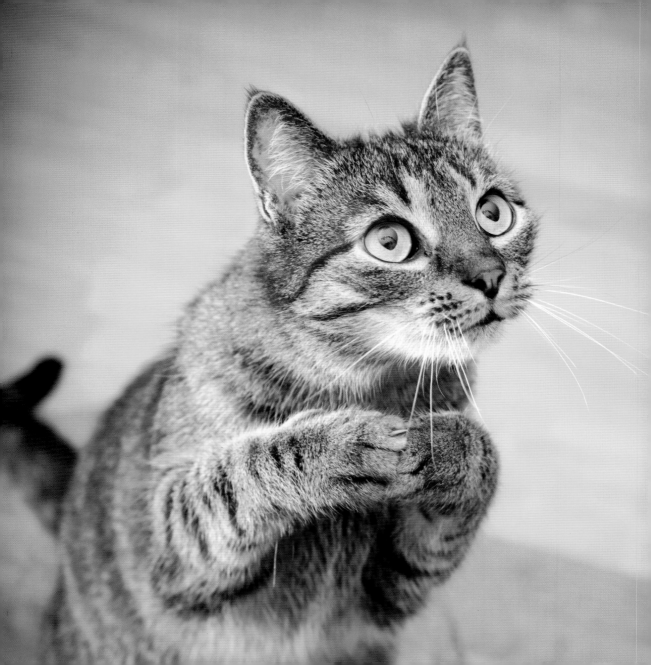

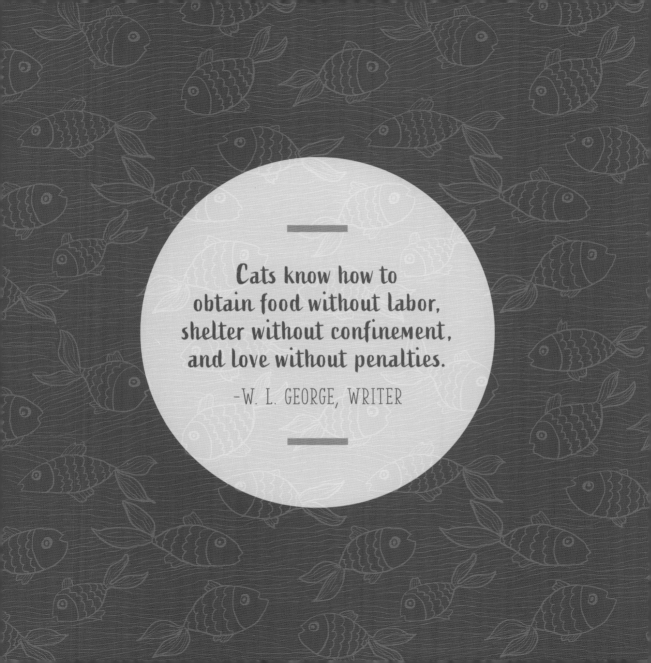

Cats know how to
obtain food without labor,
shelter without confinement,
and love without penalties.

—W. L. GEORGE, WRITER

— CATS —

CAN BE COOPERATIVE

WHEN SOMETHING FEELS GOOD,
WHICH, TO A CAT, IS THE WAY
EVERYTHING IS SUPPOSED TO FEEL AS
MUCH OF THE TIME AS POSSIBLE.

-ROGER CARAS, AUTHOR AND ANIMAL RIGHTS ACTIVIST

CATS

ARE RATHER DELICATE CREATURES

AND THEY ARE SUBJECT TO A GOOD MANY AILMENTS, BUT I NEVER HEARD OF ONE WHO SUFFERED FROM INSOMNIA.

-JOSEPH WOOD KRUTCH, AUTHOR AND CONSERVATIONIST

ANYTHING NOT NAILED DOWN IS A
CAT TOY.

-UNKNOWN

The real measure of a day's heat is the length of a sleeping cat.

-UNKNOWN

MOST CATS,
WHEN THEY ARE OUT
WANT TO BE IN,
AND VICE VERSA,
AND OFTEN
SIMULTANEOUSLY.

-LOUIS J. CAMUTI, CAT VETERINARIAN

ANYONE WHO CONSIDERS

PROTOCOL

UNIMPORTANT

HAS NEVER DEALT WITH

A CAT.

-ROBERT A. HEINLEIN, SCIENCE FICTION AUTHOR

ENEMY #1
Cats and Dogs

Most people would tell you that a dog is the opposite of a cat. They are, after all, very different creatures in terms of temperament, habit, volume, and hygiene. Dogs are lovable in their ignorance, while cats are mystifying in their discretion.

To my mind, dogs are like human babies, while cats are more like human teenagers. Dogs are innocent, a bit clueless, needy, and unfailingly loving. Like infants, they look to their owners for every need, from food to affection.

Cats, on the other hand, resemble typical human teens. They take pride in their independence (despite the fact that their owners care for and feed them), and so they tend to be a tad ungrateful. They always seem to have an "attitude"—and oh, the drama! They are masters of the silent treatment. They may, in a matter of minutes, display both great wisdom and maturity and utter silliness or infantile whining. And yet, when cats show those glimmers of vulnerability and affection, we melt. Those moments mean so much more because they are not a given; they are a luxury.

But we still wouldn't give them the car keys.

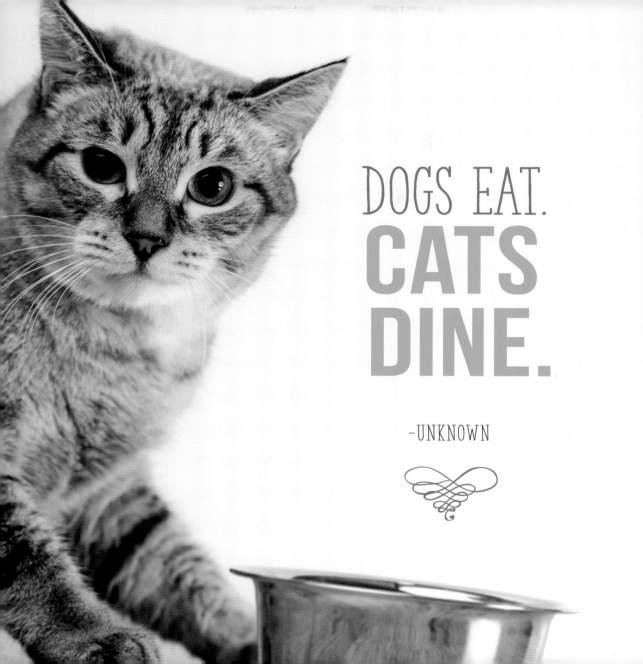

DOGS EAT.
CATS
DINE.

–UNKNOWN

DOGS COME
WHEN THEY'RE CALLED;
CATS TAKE
A MESSAGE
AND GET BACK TO YOU
LATER.

-MARY BLY, AUTHOR AND PROFESSOR

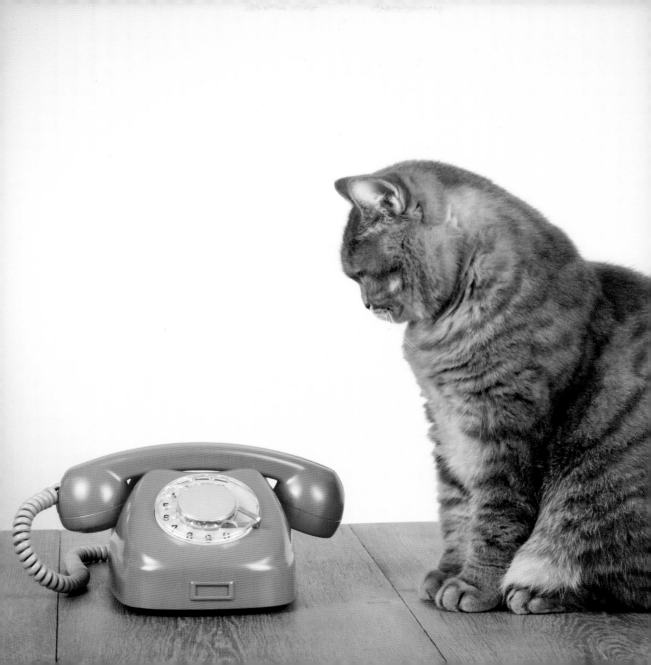

CATS ARE SMARTER THAN DOGS. YOU CAN'T GET **EIGHT CATS** TO PULL A SLED THROUGH SNOW.

-JEFF VALDEZ, TV WRITER AND PRODUCER

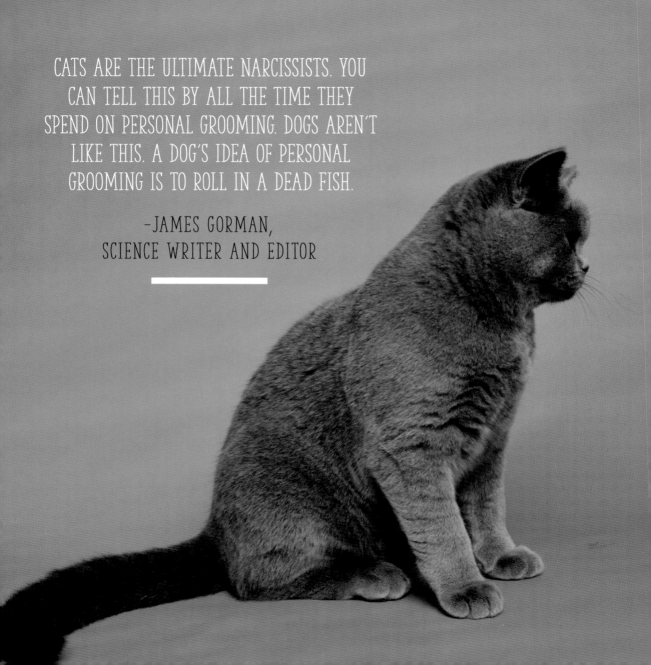

CATS ARE THE ULTIMATE NARCISSISTS. YOU CAN TELL THIS BY ALL THE TIME THEY SPEND ON PERSONAL GROOMING. DOGS AREN'T LIKE THIS. A DOG'S IDEA OF PERSONAL GROOMING IS TO ROLL IN A DEAD FISH.

-JAMES GORMAN,
SCIENCE WRITER AND EDITOR

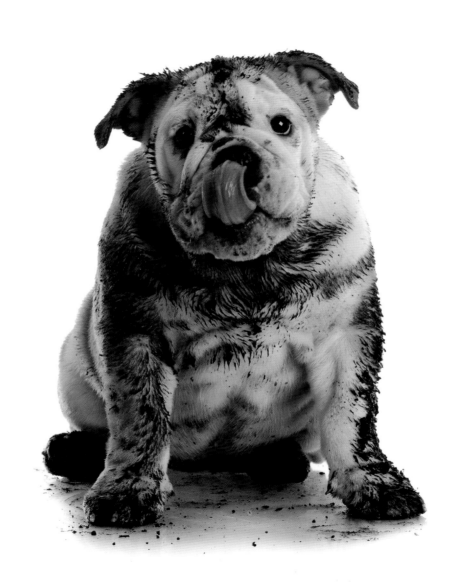

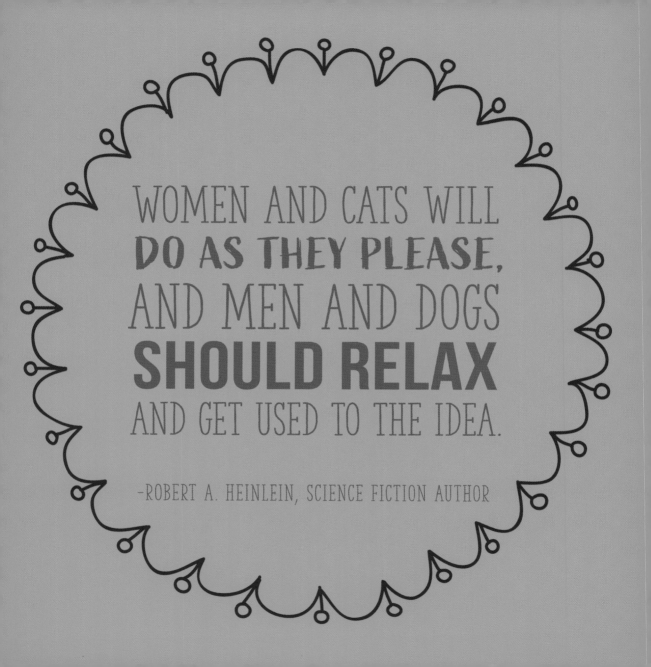

WOMEN AND CATS WILL **DO AS THEY PLEASE,** AND MEN AND DOGS **SHOULD RELAX** AND GET USED TO THE IDEA.

-ROBERT A. HEINLEIN, SCIENCE FICTION AUTHOR

IF ANIMALS COULD SPEAK,
THE DOG WOULD BE A
BLUNDERING, OUTSPOKEN FELLOW,
BUT THE CAT
WOULD HAVE THE RARE GRACE
OF NEVER SAYING
a word too much.

-MARK TWAIN, AUTHOR AND HUMORIST

DOGS HAVE
MASTERS.
CATS HAVE
STAFF.

-UNKNOWN

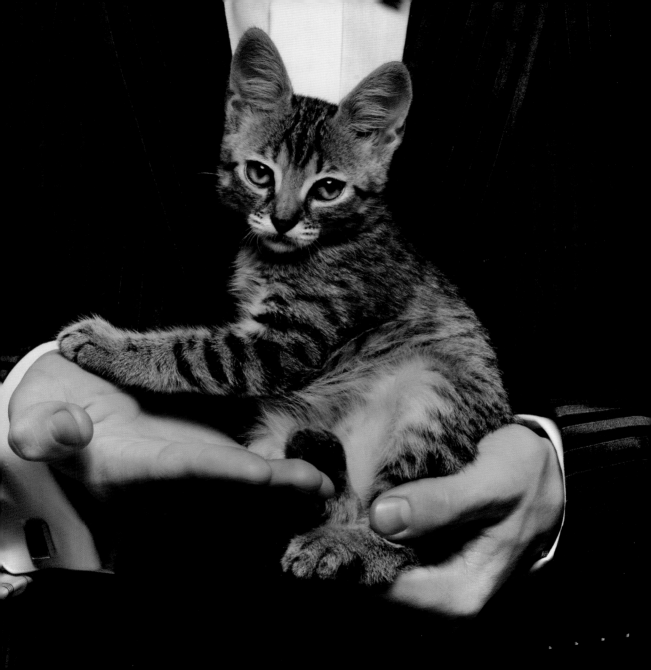

If a dog jumps in your lap, it is because he is fond of you; but if a cat does the same thing, it is because your lap is warmer.

–ALFRED NORTH WHITEHEAD,
MATHEMATICIAN AND PHILOSOPHER

DOGS
ARE LIKE KIDS.
CATS
ARE LIKE
ROOMMATES.

-OLIVER GASPIRTZ,
AUTHOR AND CARTOONIST

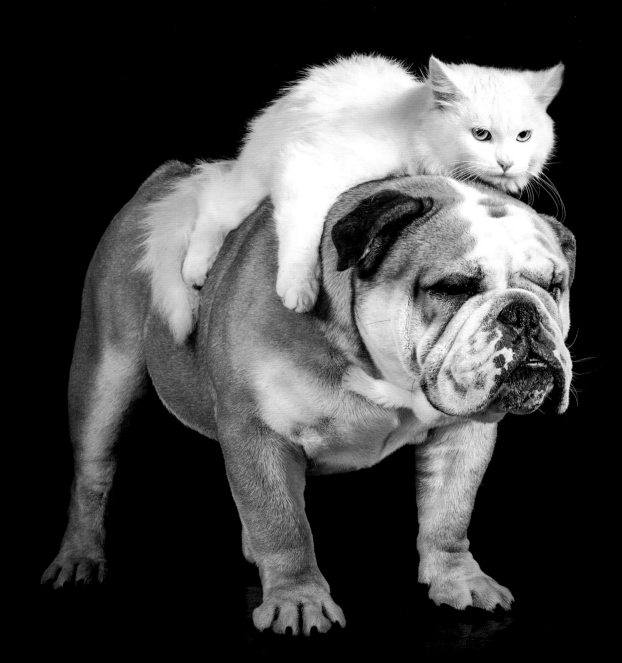

A DOG KNOWS
his master;
A CAT
DOES NOT.

-ELEAZAR B. ZADOK, RABBI

BREAK OUT THE LINT ROLLER

Cats and Cat Lovers

Cat lovers are in on a secret. There is nothing so interesting as a cat, nothing so delightful as hearing it purr, and nothing so gratifying as winning its heart. And did I mention purring? Don't even get me started on the cuteness of purring.

Our house plants may be shredded, our black pants may be covered in hair, and our laps may be permanently spoken for, but we don't mind; in fact, we love it. We love our cats.

Let the haters call us crazy, but we cat lovers know the truth—cats make the best pets.

I simply can't resist a cat, particularly a purring one. They are the cleanest, cunningest, and most intelligent things I know— outside of the girl you love, of course.

-MARK TWAIN, AUTHOR AND HUMORIST

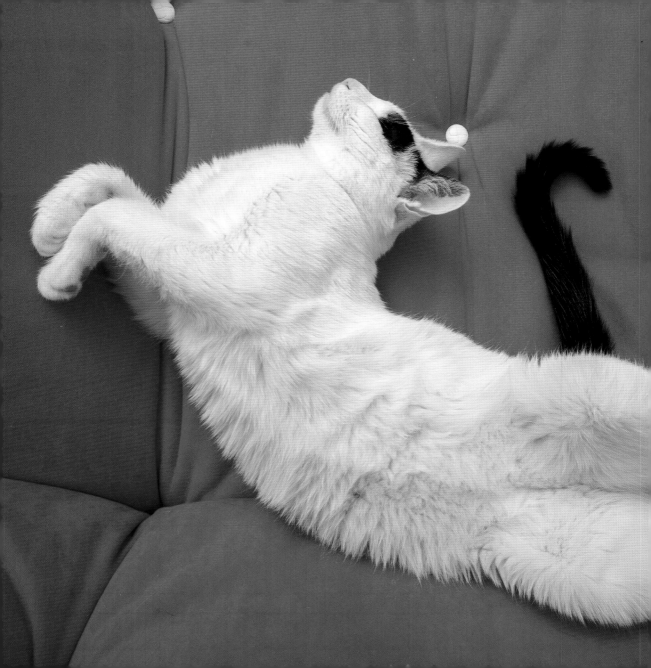

YOU HAVEN'T **LIVED** UNTIL YOU'VE LIVED WITH A CAT.

-DORIS DAY, ACTRESS AND ANIMAL WELFARE ACTIVIST

I love cats because I enjoy my home, and little by little, they become its visible

SOUL.

-JEAN COCTEAU, FILMMAKER AND WRITER

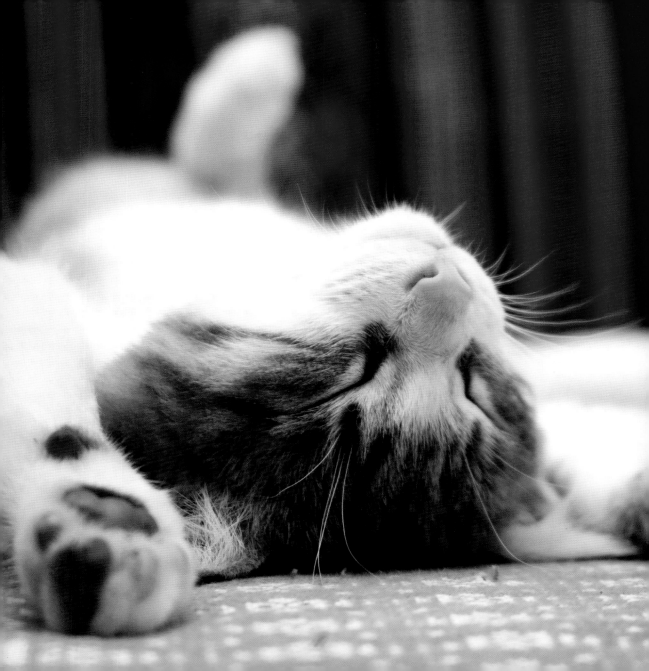

WHAT GREATER
GIFT THAN THE
LOVE
OF A CAT?

-CHARLES DICKENS, NOVELIST AND SOCIAL CRITIC

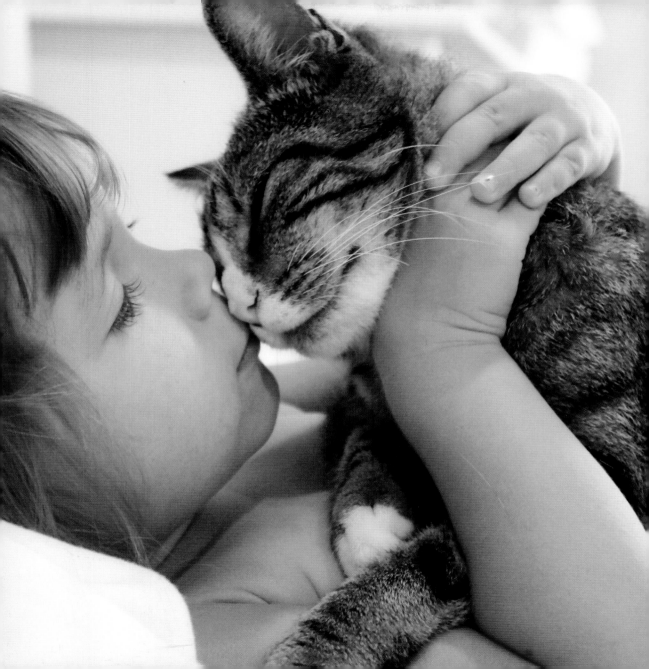

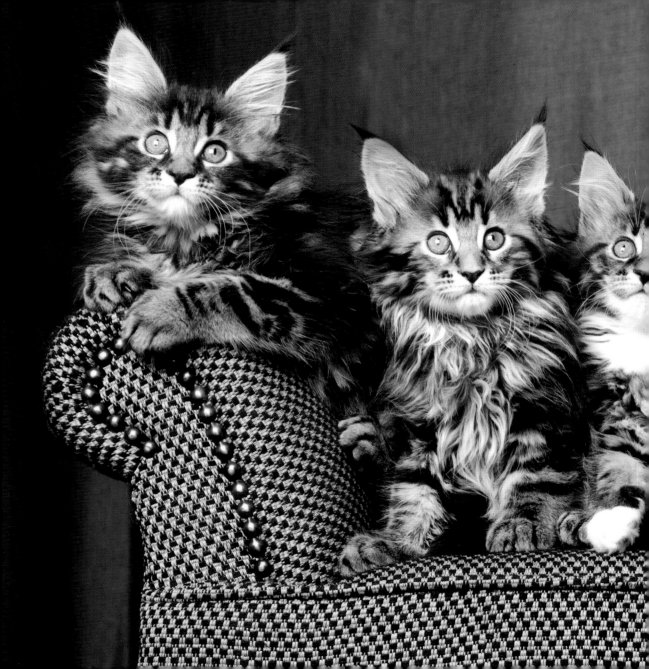

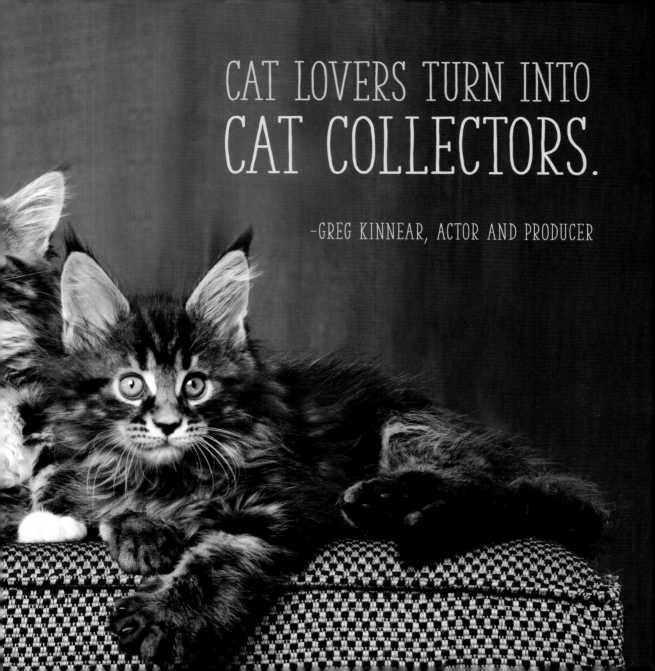

CAT LOVERS TURN INTO
CAT COLLECTORS.

-GREG KINNEAR, ACTOR AND PRODUCER

CAT PEOPLE

are different to the extent that they generally are not conformists. How could they be, with a cat running their lives?

-LOUIS J. CAMUTI, CAT VETERINARIAN

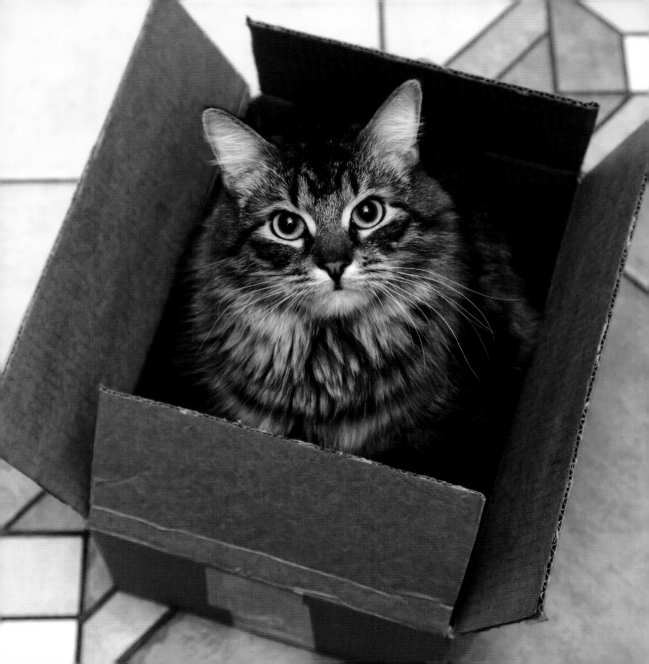

THERE ARE FEW
THINGS IN LIFE MORE
HEARTWARMING
THAN TO BE
WELCOMED
BY A CAT.

-TAY HOHOFF, LITERARY EDITOR

HOW YOU BEHAVE TOWARD
CATS HERE BELOW
DETERMINES YOUR STATUS IN

Heaven.

-ROBERT A. HEINLEIN, SCIENCE FICTION AUTHOR

THE MORE
PEOPLE
I MEET,
THE MORE I LIKE
MY CAT.

-ANONYMOUS

SMELLY CAT
Cats and Dog People

Why is it that cat lovers can still like dogs, but dog people seem completely convinced that cats are soulless, hairball-emitting demons? Is there no middle ground? Why are cats so polarizing?

Perhaps there is something fundamentally different about cat and dog people. Maybe dog people prefer a pet who wears its emotions on its "sleeve" while cat people prefer a riddle, an enigma. Maybe dog people crave energetic loyalty while cat people need quiet companionship. Or maybe it can be summed up in a single word:

Allergies.

Whatever the cause, according to veterinarian Deborah A. Edwards, this tragic schism has but one explanation: "People who don't like cats just haven't met the right one yet."

PEOPLE WHO HATE CATS WILL COME BACK AS MICE IN THEIR NEXT LIFE.

ANONYMOUS

Beware
OF PEOPLE
WHO DISLIKE
CATS.

-IRISH PROVERB

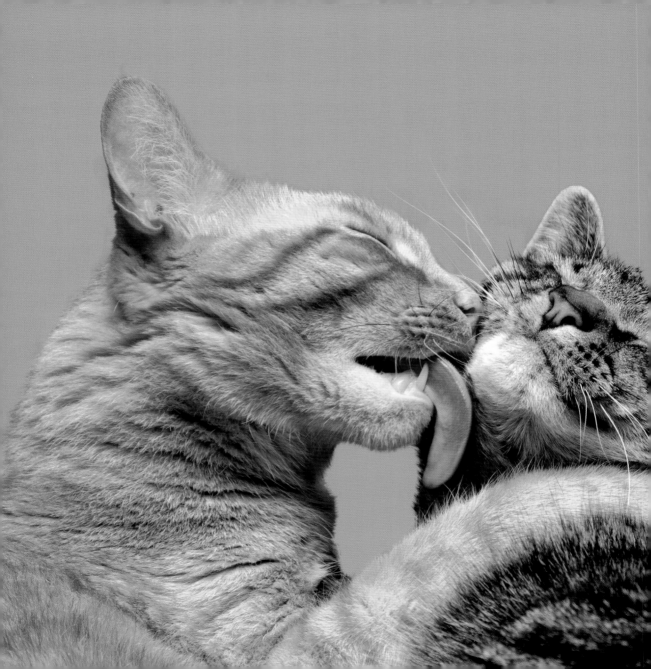

CATS

ARE'T CLEAN;
THEY'RE JUST COVERED
WITH CAT SPIT.

-JOHN S. NICHOLS,
PRINTER AND AUTHOR

LETTIN' THE CAT **OUTTA THE BAG** IS A WHOLE LOT EASIER THAN PUTTIN' IT BACK IN.

-WILL ROGERS, HUMORIST AND ENTERTAINER

Dogs will give you unconditional love until the day they die. Cats will make you pay for every mistake you've ever made since the day you were born.

- OLIVER GASPIRTZ, AUTHOR AND CARTOONIST

A DOG IS
A MAN'S
BEST
FRIEND.
A CAT IS
A CAT'S
BEST
FRIEND.

-UNKNOWN

HERE, KITTY, KITTY

Cats and Their "Masters"

When you decide to adopt a cat, what you've really done is sign a binding contract, agreeing to submit your will, your time, and your treats to the feline ruler who has entered your home. Your cat now owns you, and it will be happy to remind you of that fact if you ever happen to forget.

After all, everyone knows that "meow" is really a command to "Let ME-OUT!"

CATS WERE PUT
INTO THE WORLD TO
DISPROVE
THE DOGMA THAT
ALL THINGS WERE
CREATED TO
SERVE MAN.

-UNKNOWN

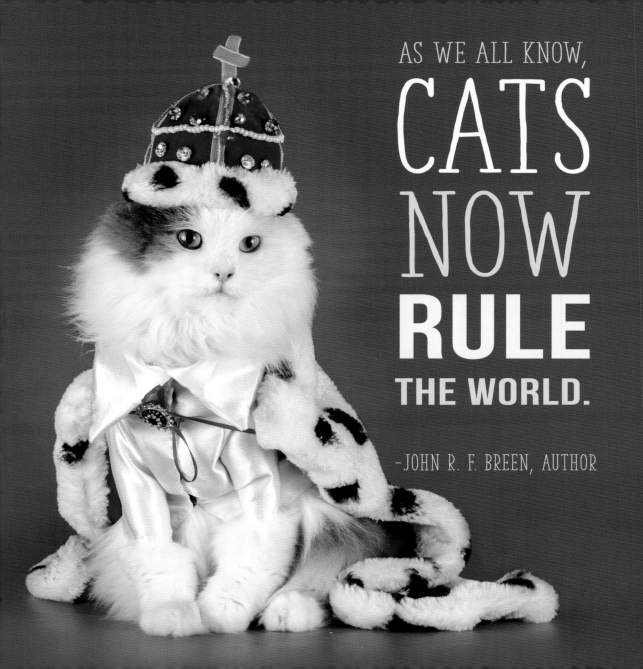

AS WE ALL KNOW,
CATS
NOW
RULE
THE WORLD.

—JOHN R. F. BREEN, AUTHOR

Cats' hearing apparatus is built to allow the human voice to easily go in one ear and out the other.

-STEPHEN BAKER,
ANIMAL BEHAVIORIST AND AUTHOR

THE CAT IS DOMESTIC ONLY AS FAR AS SUITS ITS OWN ENDS.

-HECTOR HUGH MUNRO, AUTHOR AND PLAYWRIGHT

WHEN A CAT ADOPTS YOU, THERE IS NOTHING TO BE DONE ABOUT IT EXCEPT TO **PUT UP** WITH IT UNTIL THE WIND CHANGES.

-T. S. ELIOT, POET AND PLAYWRIGHT

CATS ARE
KINDLY MASTERS . . .

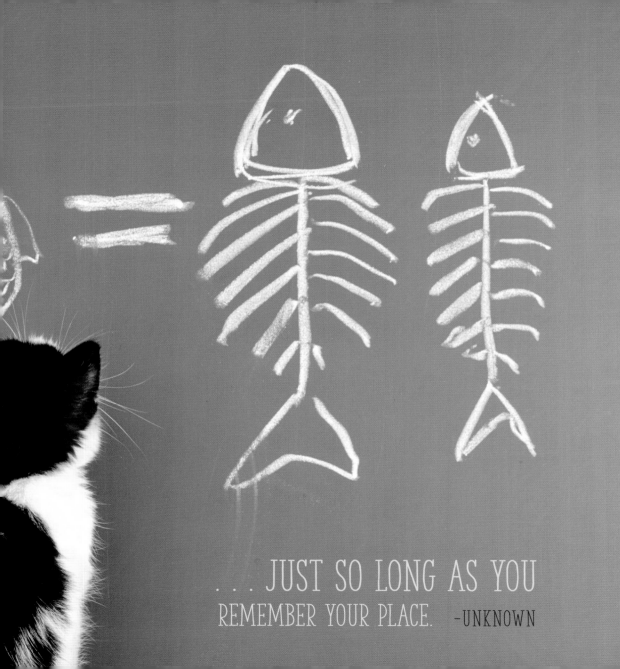

. . . JUST SO LONG AS YOU
REMEMBER YOUR PLACE. -UNKNOWN

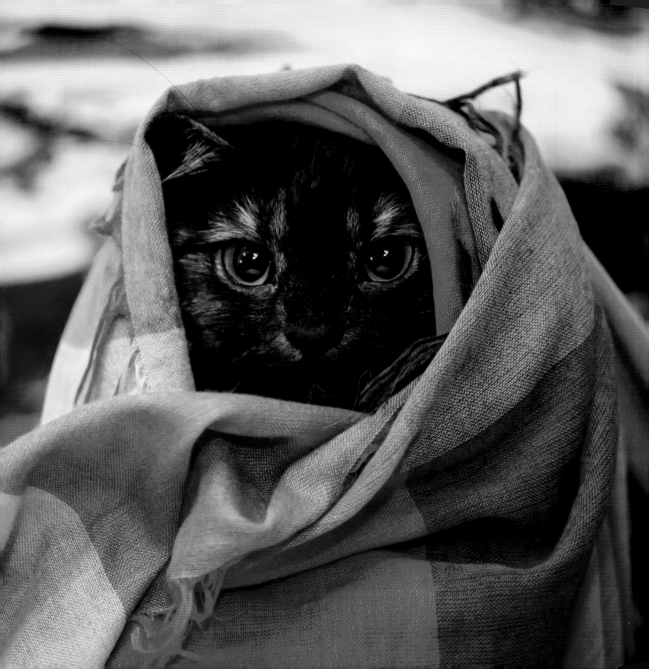

THERE ARE MANY INTELLIGENT
SPECIES IN THE UNIVERSE.
THEY ARE ALL
OWNED
BY CATS.

-ANONYMOUS

THE PHRASE DOMESTIC CAT IS AN OXYMORON

-GEORGE F. WILL, JOURNALIST AND POLITICAL PUNDIT

After scolding one's cat,
one looks into its face and
is seized by the ugly suspicion
that it understood every
word—and has filed it
for reference.

–CHARLOTTE GRAY, BIOGRAPHER

CAT'S CRADLE
Cats and Kittens

Let's be honest: is there anything cuter than a kitten? With their big eyes, furry bodies, and insatiable curiosity, kittens are by far the most irresistible creatures on the planet. Part of what makes them so adorable is their adventurous, uninhibited spirit. They openly show affection. They question everything. They fear nothing—except very loud noises.

Cats and humans actually follow a very similar maturation pattern. When we are young, we are fearless. We are open and curious and naïve, but we are blissful in our ignorance—we are kittens. The older we get, the more cautious we become. We reserve our emotions. We observe before we act. We are wiser, but we are also a little sadder—we are cats.

Kittens are born with their eyes shut. They open them in about six days, take a look around, then close them again for the better part of their lives.

-STEPHEN BAKER, ANIMAL BEHAVIORIST AND AUTHOR

THERE IS NO MORE
INTREPID
EXPLORER
THAN A
KITTEN.

-CHAMPFLEURY, NOVELIST AND ART CRITIC

IT IS IMPOSSIBLE
TO KEEP A
**STRAIGHT
FACE**
IN THE PRESENCE OF
ONE OR MORE KITTENS.

—ANONYMOUS

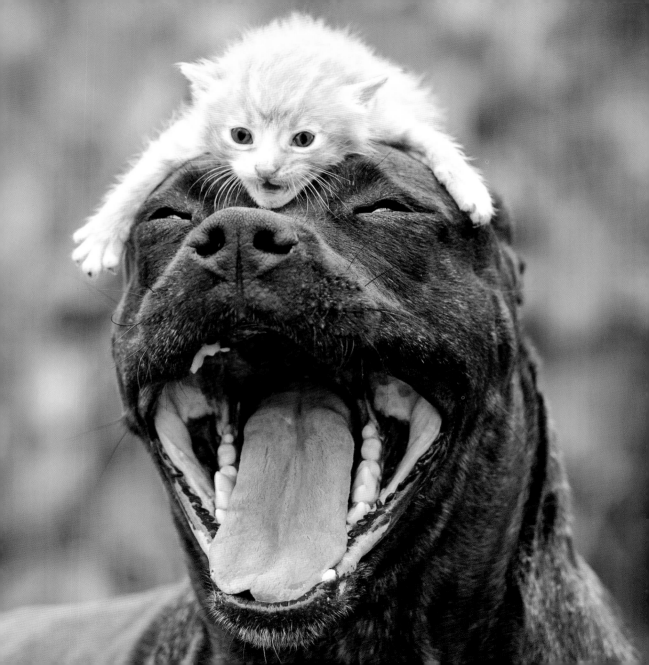

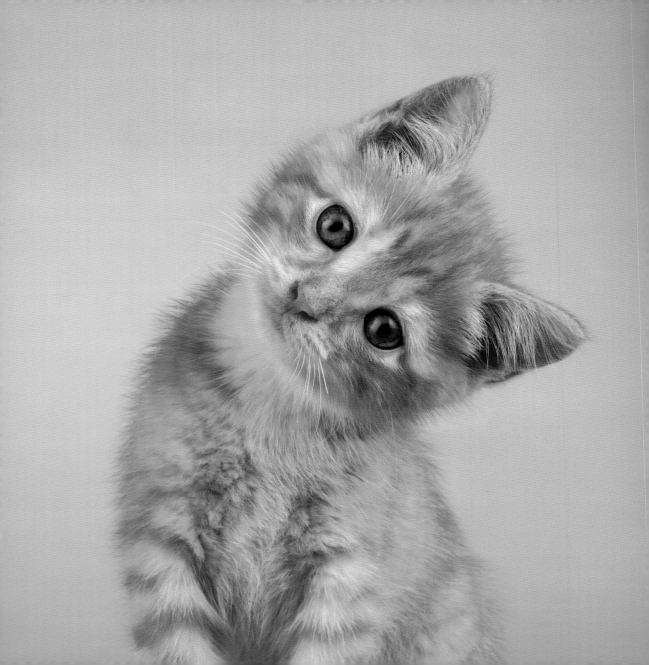

It is a very inconvenient
habit of kittens (Alice had
once made the remark) that
whatever you say to them,
they always purr.

-LEWIS CARROLL, AUTHOR
THROUGH THE LOOKING-GLASS, AND WHAT ALICE FOUND THERE

IF ONLY
cats
GREW INTO
kittens.

–UNKNOWN

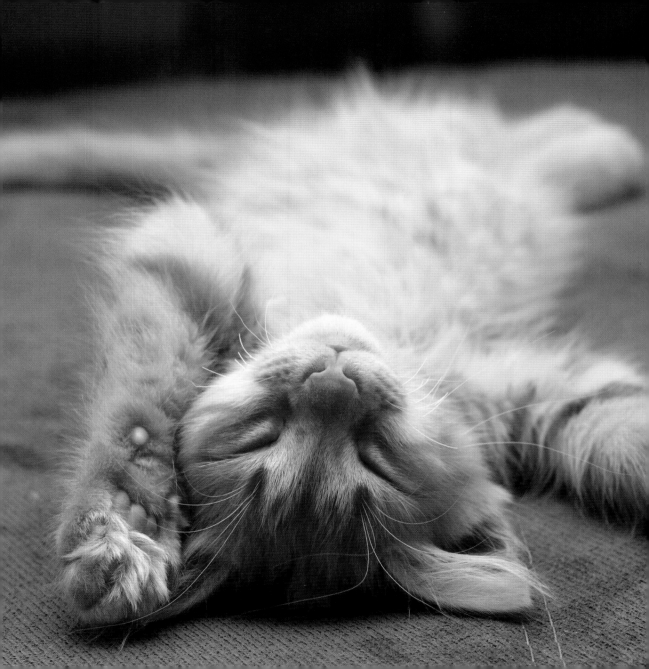

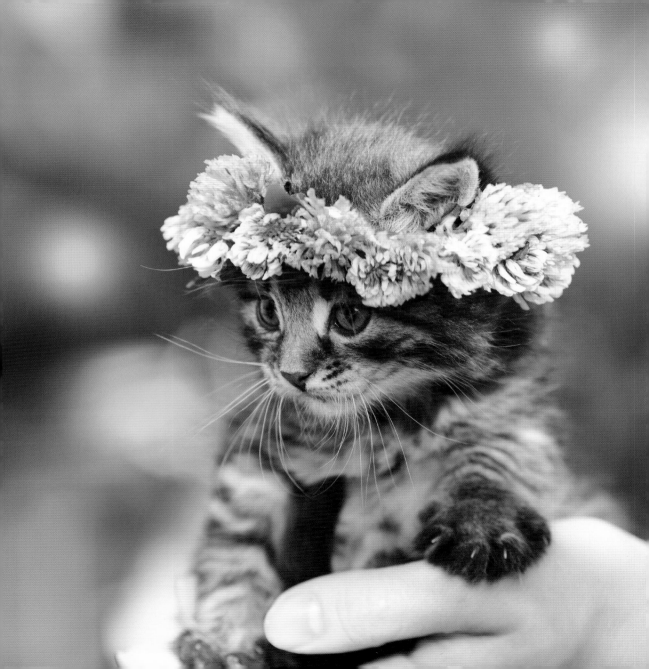

A kitten is,
in the animal
world, what a
rosebud is in
the garden.

-ROBERT SOUTHEY, POET

ONE CAT
JUST LEADS
TO ANOTHER.

-ERNEST HEMINGWAY, JOURNALIST AND AUTHOR

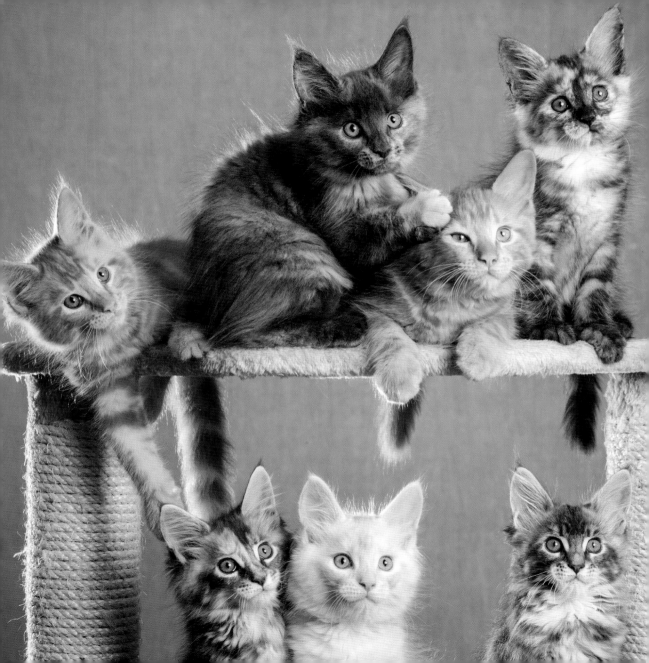

TO PURR OR NOT TO PURR?

Cats and Artists, Philosophers, and Gods

Creative, intellectual people have always been inexplicably drawn to cats. Ernest Hemingway owned more than thirty cats in his lifetime. Perhaps such artists admire the cat's natural aesthetic beauty and innate wisdom. The cat's silence and grace make it an excellent companion for writers, artists, and philosophers of all kinds.

Or maybe there is a simpler explanation. Maybe cats see themselves as philosophers, as works of art, even as gods. And maybe similarly pretentious, romantic humans are more than happy to play along. As they say, birds of a feather . . .

In nine lifetimes, you'll never know as much about your cat as your cat knows about you.

-MICHEL DE MONTAIGNE,
PHILOSOPHER AND ESSAYIST

THE CAT'S FUNCTION IS TO SIT AND **BE ADMIRED.**

-GEORGINA STRICKLAND GATES,
PSYCHOLOGIST AND AUTHOR

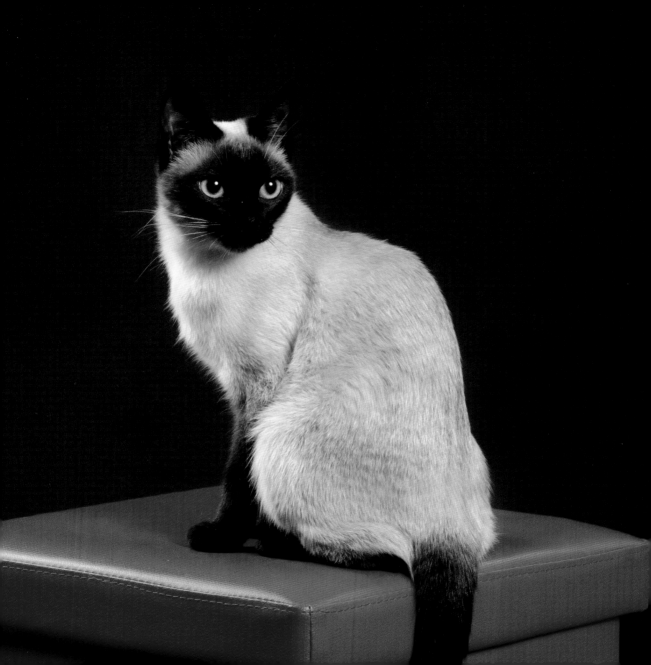

THERE ARE
TWO MEANS OF
REFUGE FROM THE
MISERY OF LIFE:
MUSIC
AND CATS.

-ALBERT SCHWEITZER,
MUSICIAN AND PHILOSOPHER

Two things are
aesthetically perfect
in the world:

THE CLOCK
AND THE
CAT.

-ÉMILE-AUGUSTE CHARTIER,
PHILOSOPHER AND AUTHOR

AUTHORS
LIKE CATS
BECAUSE THEY ARE
SUCH QUIET,
LOVABLE, WISE CREATURES,
AND CATS LIKE AUTHORS
FOR THE SAME
reasons.

—ROBERTSON DAVIES,
NOVELIST AND PLAYWRIGHT

TIME SPENT WITH CATS IS NEVER WASTED.

-UNKNOWN

COULD THE PURR BE ANYTHING BUT CONTEMPLATIVE?

-IRVING TOWNSEND, RECORD PRODUCER AND AUTHOR

I wish
I could
write as
mysterious
as a cat.

-UNKNOWN

IT ALWAYS GIVES ME
A SHIVER
WHEN I SEE
A CAT SEEING
WHAT I
CAN'T SEE.

-ELEANOR FARJEON, CHILDREN'S AUTHOR

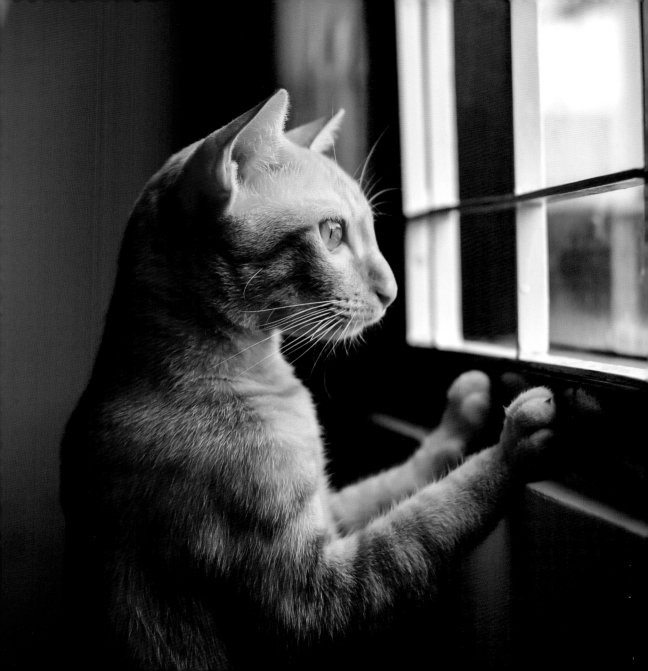

IN ANCIENT TIMES, CATS WERE WORSHIPPED AS GODS; THEY HAVE NEVER FORGOTTEN THIS.

-SIR TERRY PRATCHETT, COMIC FANTASY NOVELIST

IN THE BEGINNING, GOD CREATED MAN, BUT SEEING HIM SO FEEBLE, HE GAVE HIM THE CAT.

-WARREN ECKSTEIN, PET BEHAVIORIST AND AUTHOR

WHO CAN BELIEVE
THAT THERE IS NO SOUL
BEHIND THOSE
LUMINOUS
EYES?

-THÉOPHILE GAUTIER, POET AND ART CRITIC

I'VE MET MANY THINKERS
AND MANY CATS,
BUT THE WISDOM
OF CATS
IS INFINITELY
SUPERIOR.

-HIPPOLYTE TAINE, HISTORIAN AND PHILOSOPHER

OF MICE AND MEN

Cats and Their Human Qualities

Since cats can be so quiet, so withdrawn, cat owners often find themselves wondering, *What are they thinking about?* We tend to anthropomorphize—to attribute human emotion to their intelligent eyes, their dignified bearing, and their knowing glances.

Cats, in their feline wisdom, represent both the best and worst of humanity—though perhaps more gracefully. They are proud, but they are loyal. They demonstrate both complete contentment and utter rage. They may be sycophants, but they are independent. They are unpredictable, and yet, most of the time, we are certain we know exactly what they are thinking.

Cats must be people, too.

Way down deep, we're
all motivated by the
same urges.
Cats have the courage
to live by them.

-JIM DAVIS, CARTOONIST

THERE IS, INDEED, **NO SINGLE QUALITY** OF THE CAT THAT MAN COULD NOT EMULATE TO HIS ADVANTAGE.

-CARL VAN VECHTEN, AUTHOR, *THE TIGER IN THE HOUSE*

CATS INVENTED
SELF-ESTEEM
THERE IS
NOT AN
INSECURE
BONE
IN THEIR BOD

-ERMA BOMBECK, HUMORIST AND A

IF CATS COULD TALK, THEY WOULDN'T.

-ANONYMOUS

With the qualities of cleanliness, affection, patience, dignity, and courage that cats have, how many of us, I ask you, would be capable of becoming cats?

-FERNAND MÉRY,
VETERINARIAN AND AUTHOR

ABOUT
THE AUTHOR

Brooke Jorden is a converted cat lover. Brooke earned a BA in English and editing from Brigham Young University. The author of *I Dig Bathtime, Flamingo Flamenco*, and the Lit for Little Hands series, Brooke is also the managing editor at Familius. She resides in Utah with her husband, their children, and their adorable cat, Sadie.

ABOUT
FAMILIUS

Familius is a book publisher dedicated to helping families be happy. We believe that the family is the fundamental unit of society and that happy families are the foundation of a happy life. The greatest work anyone will ever do will be within the walls of his or her own home. And we don't mean vacuuming! We recognize that every family looks different and passionately believe in helping all families find greater joy, whatever their situation. To that end, we publish beautiful books that help families live our 9 Habits of Happy Family Life: Love Together, Play Together, Learn Together, Work Together, Talk Together, Heal Together, Read Together, Eat Together, Laugh Together

Website: www.familius.com
Facebook: www.facebook.com/paterfamilius
Twitter: @familiustalk, @paterfamilius1
Pinterest: www.pinterest.com/familius